D1539408

SEEING THINGS SIMPLY

PORTRAITS

LESSONS & EXERCISES TO DEVELOP
YOUR PAINTING & DRAWING TECHNIQUE

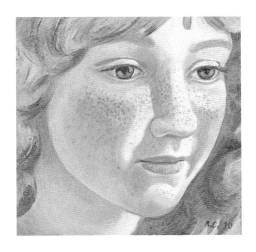

ROSALIND CUTHBERT

CHARTWELL
BOOKS INC

A QUINTET BOOK

Published by Chartwell Books
A Division of Book Sales, Inc.
110 Enterprise Avenue
Secaucus, New Jersey 07094

This edition produced for sale
in the U.S.A., its territories
and dependencies only.

ISBN 0-7858-0064-6

This book was designed and produced by
Quintet Publishing Limited
6 Blundell Street
London N7 9BH

Creative Director: Richard Dewing
Designer: Ian Hunt
Project Editor: Helen Denholm
Editor: Hazel Harrison
Photographer: Paul Forrester

Typeset in Great Britain by
Central Southern Typesetters, Eastbourne
Manufactured in Hong Kong by
Regent Publishing Services Limited
Printed in China

CONTENTS

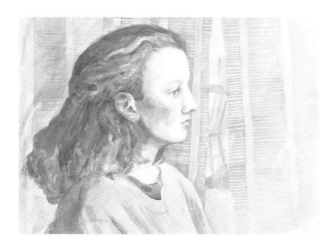

INTRODUCTION

THE HUMAN FACE, with all its many individual variations, is not the easiest subject to draw and paint, but it is a very satisfying one. The main task of the portrait painter is to produce a good likeness of the person, and this is not just a matter of getting the features right – you need to be able to convey something of the sitter's character as well. Some fortunate people have the happy knack of being able to "catch a likeness" without effort, but most of us, myself included, have to work hard at it, learning by trial and error.

There is no magic formula to enable you to become a portrait painter overnight, but there are a few "tricks of the trade," such as measuring, which are used by the majority of portrait painters – even professionals can make mistakes. I have explained some of these, as well as providing what I hope is some useful basic information about the shape and proportions of the head

and the placing of the features. Even though faces vary enormously, it helps to understand the underlying structures, and to have a standard against which to check individual differences. Also, a portrait will not fully succeed unless the head, face, and features are believable in terms of three-dimensional form.

I paint in several different media, normally using oils for commissioned portraits and pastels or watercolors for more informal paintings, and I have chosen a selection for this book. Although I love watercolor, I would urge you not to use it for your first attempts; it is a tricky medium to handle, and can easily lead to discouragement. It is best to start by drawing, or if you want to launch into paint immediately, use an opaque medium such as oils or acrylics that can be easily corrected. And above all, do not let failures put you off – making mistakes is an essential part of the learning process.

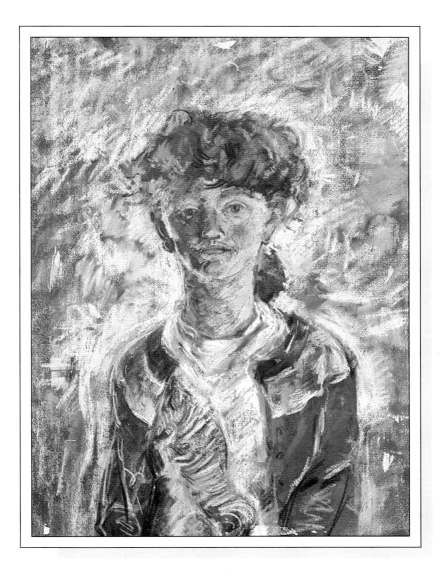

PROPORTIONS OF THE FACE

IT IS OBVIOUS that no two faces are the same – we would not be able to recognize friends and relations if this were not the case – but there are some general rules about proportions that are useful to bear in mind. Once you have understood these it is easier to grasp how and in what way people depart from this "ideal."

Beginners often make the features too large in relation to the head, and place eyes too high. As you can see from these drawings, the top of the eyes mark the rough halfway point, which is a good rule of thumb when you are beginning a drawing.

It is also useful to remember that the ears nearly always line up with the tops of the eyes and the bottom of the nose. You can see this clearly in the profile view, which also shows the surprising size of the back of the head. This is another common pitfall when dealing with profiles or three-quarter views; because the head is often obscured by hair, it is easy to misjudge its shape.

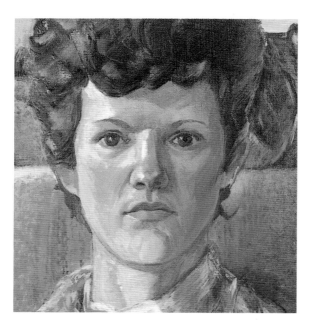

LEFT

In this front view, the nose and ears are in line. Note the distance between the base of the nose and the top lip, and the space between the lower lip and the chin line. The high hairstyle hides the skull line. The eyes are an eye's length apart, and the mouth corners are in line with the inner edges of the irises.

OPPOSITE

It is useful to bear in mind some facts about the general proportions of the head and the alignment of features. This makes it easier to analyse individual differences, such as very wide-spaced or large eyes or a small mouth.

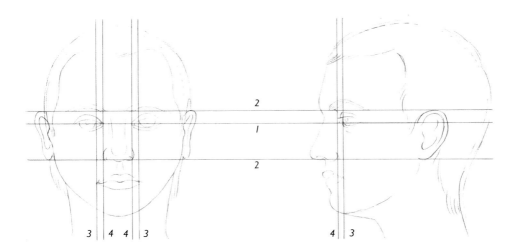

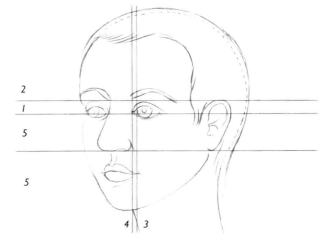

1 Middle of the eyes approximately halfway down the head.

2 Ears line up with eyes and nose.

3 Pupil of the eye aligns with the corner of the mouth.

4 Inside edge of the eyebrow lines up with the corner of the eye.

5 Space between the bottom of the nose and the chin is greater than that between the bottom of the nose and the eyes.

REAL PEOPLE

ONCE YOU HAVE LEARNED the basic rules about head shapes and proportions you can start to look for individual variations between different people, which is the first step towards achieving a likeness. Notice the striking differences between all the heads shown here.

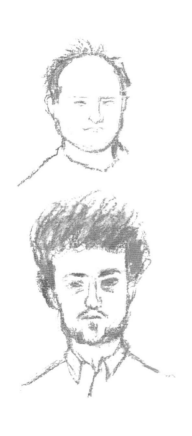

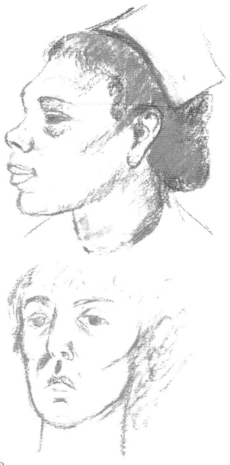

You will learn a lot by making quick sketches of this kind; you can draw people in cafés, shops or bus shelters, or you could try drawing faces from photographs in magazines and newspapers. If you do this, though, don't try to make detailed copies – the point is to analyse the faces, and see if you can tell what it is that makes each one special and how in particular they depart from the "norm." Does one have a much wider mouth than the other, for instance? Or small eyes that are set closer together?

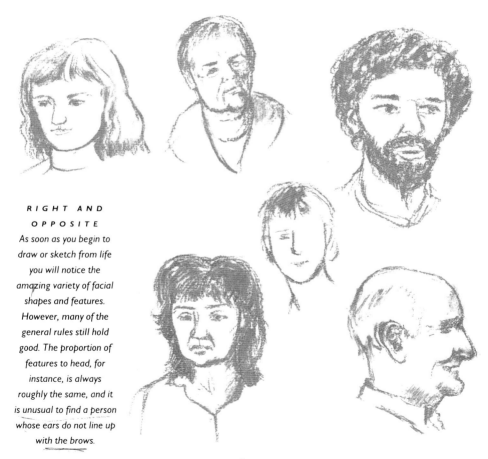

RIGHT AND OPPOSITE
As soon as you begin to draw or sketch from life you will notice the amazing variety of facial shapes and features. However, many of the general rules still hold good. The proportion of features to head, for instance, is always roughly the same, and it is unusual to find a person whose ears do not line up with the brows.

BE YOUR OWN MODEL

THE NEXT THING TO DISCOVER is what happens to the features when the head is seen at an angle. If you are fortunate enough to have someone who will pose for you, try asking them to look up and then down, then to one side and the other. If not, you can draw yourself as I have done. You will notice that as soon

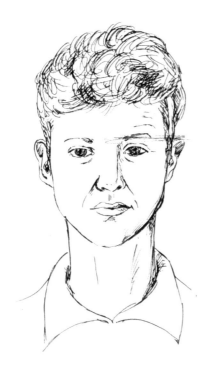

ABOVE
Looking straight ahead.

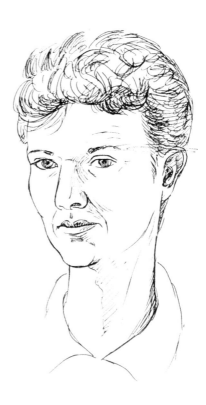

ABOVE
Head turned slightly.

as the head moves, the proportions change because it is seen in perspective. When a person is looking to one side you see more of the back of the head and less of the features. Looking down has the effect of compressing the features, and you also see more of the top of the head. Looking up reduces the apparent size of the top of the head. Of course, you cannot look up or down very far when you are drawing yourself, but it will still provide extremely valuable drawing practice.

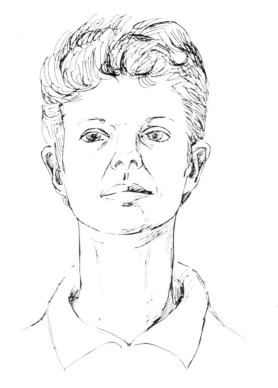

A B O V E
Looking up.

A B O V E
Looking down.

HEAD AND SHOULDERS

IT IS SELDOM POSSIBLE to achieve a convincing drawing or painting if you draw the head first and then try to join it onto the neck and shoulders. The head and neck should be seen as a single, interconnected unit, as every movement of the head affects the muscles that join the two together. Make drawings of heads and necks from the back and side as well as from the front. Although back views as such do not play a major role in portraiture, the more positions you can draw heads and necks in, the better you will understand their structure.

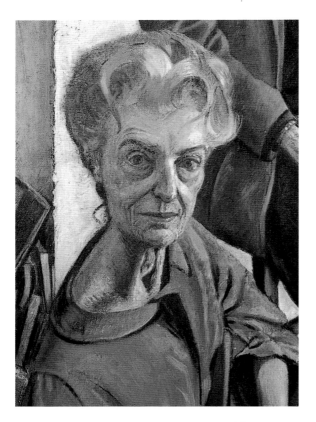

L E F T
The model's neck is clearly visible from this angle, and the dress collar shows the width of her shoulder.

O P P O S I T E
It is helpful to establish the shapes of the head and neck before you begin to define the features. Notice how the head forms an oval, very much like an egg in shape, which sits on top of the cylinder of the neck. Seen from the back the egg shape is less pronounced because the bottom of the jutting cranium is higher than the chin, which forms the bottom of the oval in a front view. The egg shape also changes when the head is tilted or viewed from an angle because it is seen in perspective.

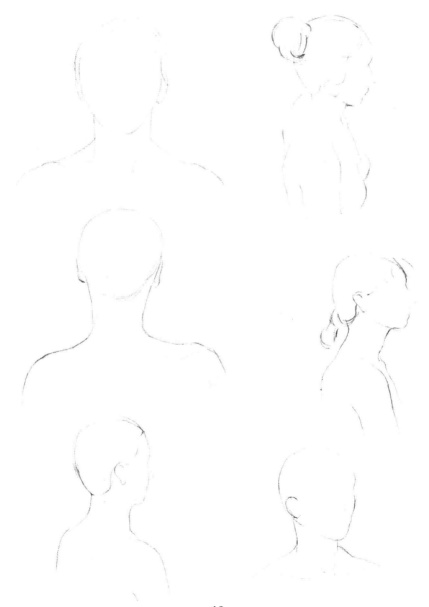

BABIES

THE PROPORTIONS OF BABIES are very different from those of adults. Not only are their heads much larger in relation to their bodies, but they are also larger in relation to the features, which thus appear to be set closer together. Because babies' skulls have a more fleshy covering, the cheekbones and jawbones which model the adult face are hidden, and so their faces are rounder. Babies' eyes are generally lower in the face than those of adults,

being just below the halfway point.

You may find it helpful to make sure of certain key proportions by measuring them. In the drawing below lines have been drawn between the ear and mouth, the mouth and nose, the nose and corner of the eye, and back again to the ear. These lines join to form a quadrilateral of a particular shape, which changes with the viewpoint chosen – in the profile view it becomes more elongated.

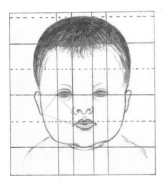

ABOVE
Measuring the spaces
between features helps
you to position them
accurately.

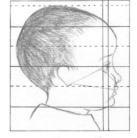

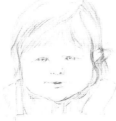

BELOW LEFT
AND OPPOSITE
Although measuring
devices are very useful in
portraiture (there is more
about them on pages
26–7), they are no
substitute for direct
observation. Both this
pencil drawing (bottom
left) and the pastel
sketch (opposite) were
made direct from life, the
"model" being my
daughter, in her babyhood
and infancy.

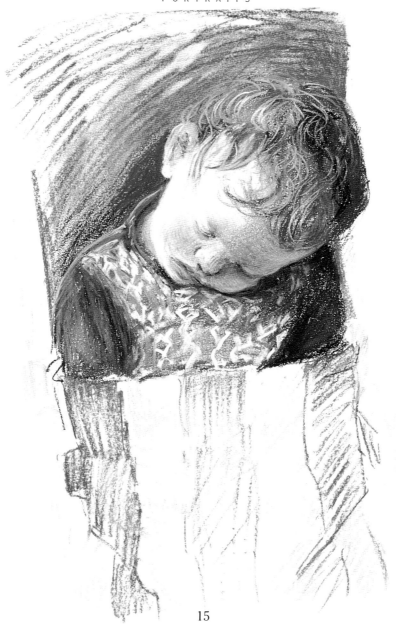

OLDER CHILDREN

As CHILDREN GROW, the covering of fat reduces, the features begin to occupy a more prominent position, and the proportions become more like those of an adult. If you look back at pages 14–15 and compare the two quadrilaterals, you will notice particularly that the line from the bottom of the nose to the eye is longer in the older child, and that from mouth to ear more acute than it appears in the baby.

Children are a rewarding subject for portraiture, but you usually have to work quickly – or paint them while they are asleep or watching television – as they are not the most patient of models.

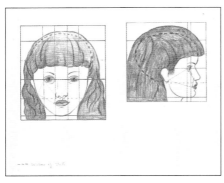

A B O V E
As children grow older the proportions change, and the features become more clearly defined.

R I G H T A N D O P P O S I T E
For these two sketches I chose watercolor, which is well suited to the delicacy of the subject as well as being ideal for rapid impressions.

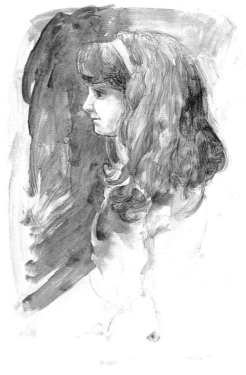

16

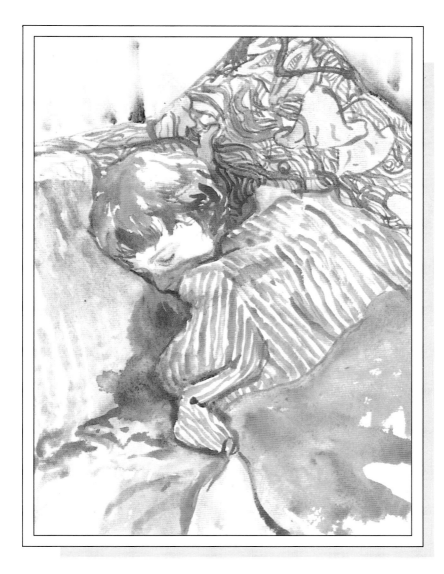

Eyes

Before you begin to consider how to "get a likeness" in a portrait you need to understand the basic structures – not only of the face and head, but also of the individual features. Eyes are often the most noticeable and dramatic aspect of a person's face, and beginners therefore tend to give them too much prominence, often simplifying them into flat oval shapes with a circle in the middle for the iris, unrelated to the eyelids, eye sockets, and brows.

The eye itself is a sphere, much of which is hidden away behind the eyelids and protected by the skull above and below. Even when the eye is fully open, you can see only a small part of this sphere, but it is vital to remember that you are drawing or painting a curved surface, not a flat one.

Practice drawing your own eyes, and perhaps those of friends if they will sit for you. You might like to try copying eyes and other features from reproductions of famous portraits, which will teach you a lot about expression. The drawings opposite were done from Old Master paintings.

R I G H T
In this straight-on view, the top lid partially covers the iris, but a little white is visible above the bottom lid. In some people, the bottom lid will also cover part of the iris.

R I G H T
As the eye turns upwards much more of the white is visible, and the size of the top lid decreases.

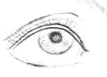

R I G H T
In this three-quarter view the eye is seen in perspective, and thus changes shape. Notice how much more white is visible at the outer edge.

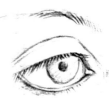

R I G H T
With the head turned away, more of the lid and eyelashes are visible.

18

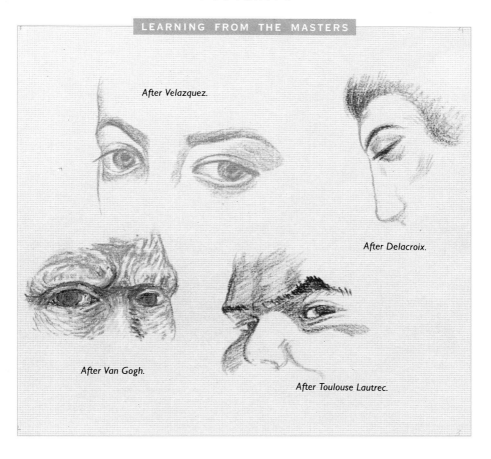

After Velazquez.

After Delacroix.

After Van Gogh.

After Toulouse Lautrec.

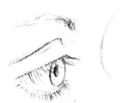

LEFT
In a side view, the curvature of the eyeball is very apparent.

RIGHT
With the eye almost closed, the top lid follows the curve of the eyeball.

19

NOSES

THE NOSE, jutting out in the center of the face, forms a link with all other parts of it, and is therefore of crucial importance. The top of the nose makes a bridge between the eyes; the sides of the nose slope down into the cheeks; and the nostrils link with the upper lip and mouth.

Noses, like eyes, are often caricatured – drawn as two lines with black holes for the nostrils, which gives little sense of shape and form. If you look at your own nose in the mirror, you will see that it is roughly triangular – narrow at the top and widening out to a rounder shape at the tip, with the wings of the nostrils curving in at the sides. Practice drawing your own nose, looking up, then looking down, and then at different angles. Try also drawing from Old Master portraits, as in the examples opposite.

LEFT
Seen from the front, the triangular shape of the nose is quite clear.

LEFT
A profile view shows the individual shape of the nose, but less of its structure.

RIGHT
In the three-quarter view you can see the narrow, flat plane forming the bridge of the nose, and also the way the wings of the nose curve into the nostrils.

RIGHT
With the head turned slightly away, the nose is partially obscured by the cheek and eye.

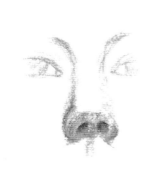

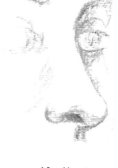

After Millais.

After Manet.

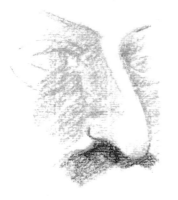

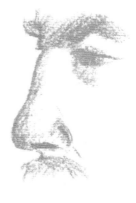

After Gauguin.

After Degas.

MOUTHS

MOUTHS ARE a particularly important feature in portraiture because they are responsible for a great deal of the expression of the face. They vary as widely as other facial features, but they all have the same basic structure, which it is important to understand.

Beginners often show mouths, like eyes, as flat shapes, but they are not flat; the lips follow the shape of the jaws and of the teeth behind them. The sides of the mouth are two planes, which have their high point at the "Cupid's bow" in the center of the mouth and then curve gently into the cheek. This curve is the reason for the steep recession you notice at the far side of the mouth in a three-quarter view. Draw your own mouth in a mirror, and practice mouth shapes by drawing from photographs or from the work of other artists. Draw men's and women's mouths, as there are usually differences – men's lips are often thinner and flatter than those of women, making a more obvious line where the lips meet.

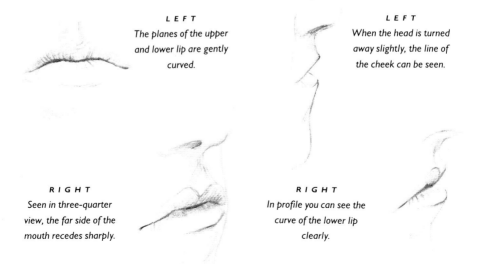

LEFT
The planes of the upper and lower lip are gently curved.

LEFT
When the head is turned away slightly, the line of the cheek can be seen.

RIGHT
Seen in three-quarter view, the far side of the mouth recedes sharply.

RIGHT
In profile you can see the curve of the lower lip clearly.

After Van Gogh.

After Velazquez.

After Renoir.

After Goya.

EARS

THE EAR IS QUITE A COMPLEX FORM, and for that reason is often treated in too much detail or presented as a separate entity, unrelated to the overall structure of the head. Ears can usually be simplified in a portrait – what is important is to get the placing and size right (see pages 6–7) and to give a realistic impression of the way the ears emerge from the skull. Ears are surprisingly varied – in some people they stand out at an angle and are clearly visible in a frontal view; some ears lie almost flat to the skull; some have more obvious lobes than others, and so on.

Practice drawing ears as often as you can. Start with a straight-on view (so the ears will be in profile), where you can clearly see the whorling curves and the way they relate to the earhole. Then draw ears from a three-quarter view, which is the one you are most likely to encounter in a portrait. Look at other artists' drawing and paintings, and copy them if you want to. You can also use yourself as a model; it is rather more difficult than drawing your own nose or mouth because the ears are positioned on the side of the head, but you can see a side view by using two mirrors.

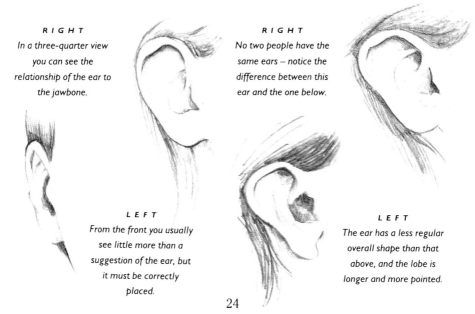

R I G H T
In a three-quarter view you can see the relationship of the ear to the jawbone.

R I G H T
No two people have the same ears – notice the difference between this ear and the one below.

L E F T
From the front you usually see little more than a suggestion of the ear, but it must be correctly placed.

L E F T
The ear has a less regular overall shape than that above, and the lobe is longer and more pointed.

24

After Manet.

After Gauguin.

After Pissarro.

After Cézanne.

GETTING THE LIKENESS

THE FIRST CONCERN of the portrait painter must always be to make a drawing or painting that is clearly recognizable as an individual person, so you must train yourself to look for the important elements. It is not just a matter of how large or small someone's nose is – before you look at features you need to establish what shape the sitter's face is. Some faces are square, others are round; some are smooth ovals, others are more angular, with prominent cheekbones.

Draw the overall shape of the face first, then look at the features. The relationship of the features – the distance between the eyes and the bottom of nose, and that between the nose and chin and so on – is just as important as the features themselves, and you can work this out by measuring, as shown opposite.

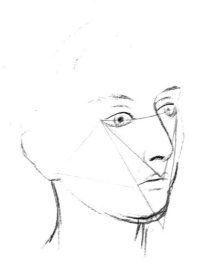

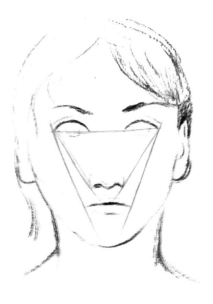

ABOVE LEFT AND RIGHT
Some portrait artists use a system of triangles, first measuring the distance between the eyes, then from *the eyes to the chin, and from the eyes to the mouth. Notice that in the three-quarter view the top line is curved, as the face is seen in perspective.*

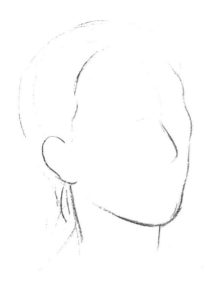

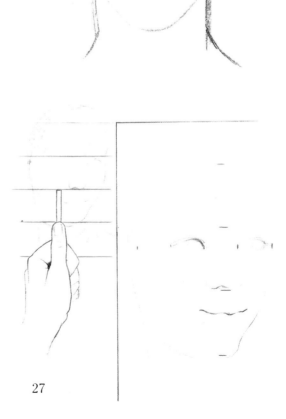

A B O V E L E F T A N D R I G H T

Draw the overall shape first. If you are taking a three-quarter view, do not forget that the features will be seen in perspective, so mark in a curved guideline that will give you the position of the eyes.

R I G H T

Hold up your pencil at arm's length and check the distance between the features, dividing the face into segments. This will show you whether, for example, the space between the chin and the top of the mouth is larger or smaller than that between the mouth and eyes.

27

BUILDING UP FORM

PORTRAITURE IS not just about drawing or painting features and face shapes accurately; you must also describe the forms, giving an impression of the structure, solidity and three-dimensionality of the head. So when you pose a portrait model – or yourself, if you are doing a self-portrait – think carefully about the lighting, since it is this that illuminates the model's form.

The kind of lighting used for the majority of portraits is called three-quarter, which means that the light comes from above and slightly to one side of the model, thereby lighting three-quarters of the face and producing good areas of shade to describe the forms.

Light coming directly from the side can create dramatic effects, throwing half the face into shadow; while front lighting reduces shadow, and therefore tends to flatten the forms. If you are working by natural light, posing your model near a window, try out different positions and see how changes in the direction of the light affect the way you perceive the forms.

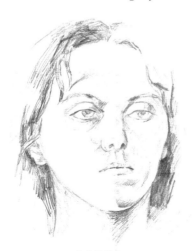

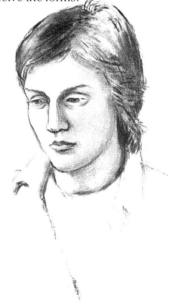

A B O V E

In this pencil drawing the main light source is on the left, but because it is reasonably gentle, the other side of the face is not in deep shadow.

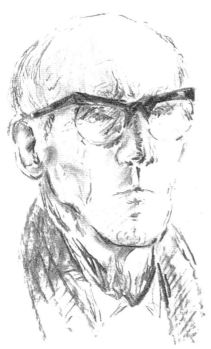

LEFT AND BELOW
In these charcoal drawings side light accentuates the bony angularity of the head.

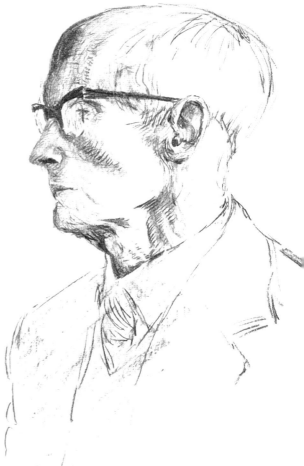

OPPOSITE
Three-quarter lighting here models the nose and eyes strongly. The drawing is in charcoal and pastel, giving an impression of color without being specific.

HAIR

HAIR CAN OFTEN CREATE problems, particularly if the hairstyle is elaborate, as it is easy to become so fascinated by its texture or by the direction of individual curls and waves that you lose sight of the shape of the skull beneath. It is often a good idea to indicate where you think the surface of the head is even if you cannot see it; this will help you to treat the hair as a covering for the head and not as a separate feature.

The hairline is important in defining the perimeters of the face – as hairdressers and makeup artists know, the whole shape of the face can be altered by a change in the hairline – so indicate this at an early stage in your drawing or painting.

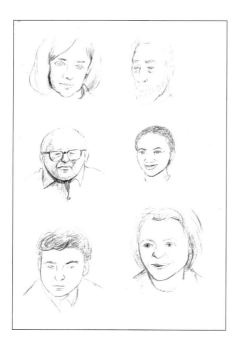

A B O V E
Hair studies in pencil.

B E L O W
The hair in this pen and ink drawing is a strong decorative element, but it is still related to the shape of the head.

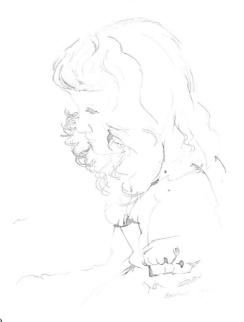

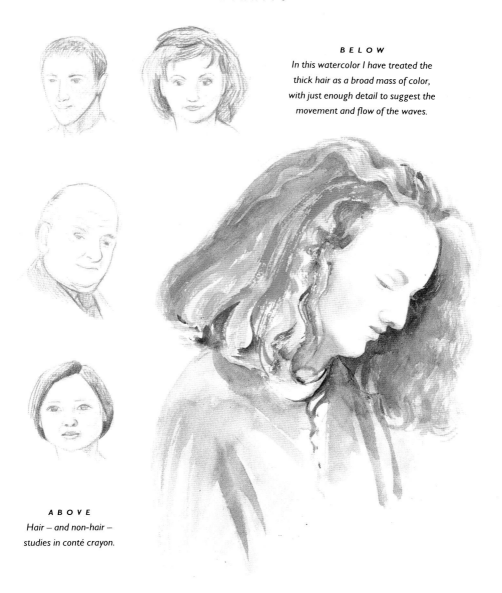

In this watercolor I have treated the thick hair as a broad mass of color, with just enough detail to suggest the movement and flow of the waves.

ABOVE
Hair – and non-hair – studies in conté crayon.

FACIAL HAIR

UNLESS YOU ARE VERY CAREFUL, beards and moustaches can often look "stuck on," so always remember that they grow from the face, even if they sometimes take rather unexpected forms and directions. Moustaches are not usually difficult, as they follow the line of the upper lip, but beards can often disguise the shape of the chin completely – men with weak chins sometimes grow beards for this very reason. So, if your subject is bearded, look for the overall shape made by the face together with beard rather than trying to draw the face and adding the beard onto it.

RIGHT

The hair, beard, and moustache are lightly scribbled in with charcoal, giving an indication of texture as well as describing the overall shape. Pastel color was used for the skin.

ABOVE

This pencil drawing depicts an unusual facial hair fashion, with moustache and sideburns almost joined together. Notice, though, how they define the shape of the face rather than disguising it.

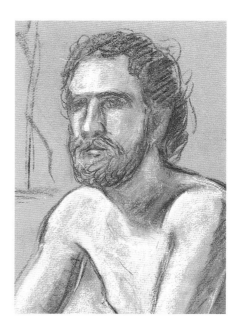

OPPOSITE

In this watercolor, light brushstrokes below the mouth hint at the chin below the luxuriant growth of beard.

32

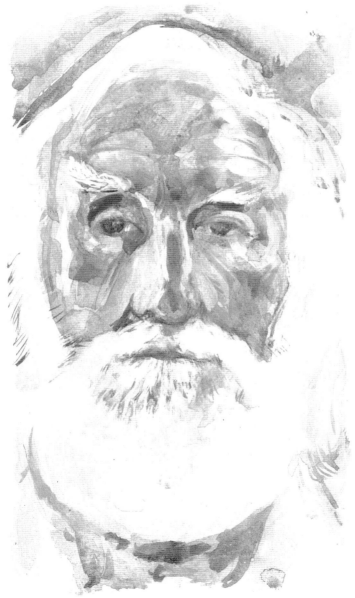

EYEGLASSES

YOU MIGHT THINK there were enough problems in portraiture without having to cope with "face furniture" as well, but at some stage you will certainly find yourself drawing or painting a bespectacled sitter. In fact, eyeglasses can make life easier, as they provide a ready-made "key" for positioning the eyes and nose, so do not make the mistake of trying to draw the face first and then adding the eyeglasses. See the eyeglasses as part of the face from the outset, and when you are drawing the eyes beneath them look carefully at the way they connect. Do the tops of the frames, for example, sit above the eyes at eyebrow level? Or are they lower down, obscuring part of the eyes?

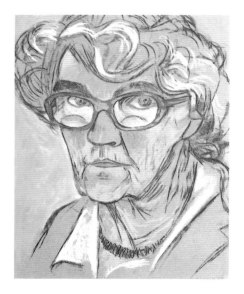

B E L O W
In these charcoal and pastel drawings the sitter is looking down, so the eyeglass lenses are seen in sharp perspective.

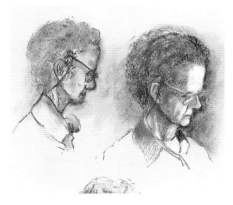

A B O V E
These strong lenses reflect light as well as magnifying the eyes. This gives an extra intensity to the drawing, for which charcoal and pastel were used in combination.

O P P O S I T E
Notice how the line made by the tops of the frames in this picture establishes the angle of the head and the position of the eyes. The drawing is in pastel.

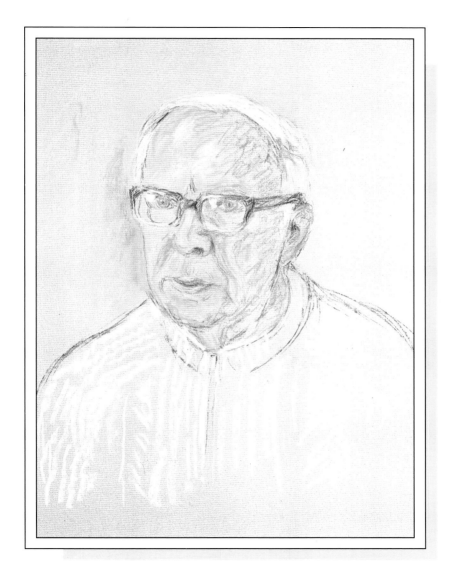

MAKEUP

LIKE HAIRSTYLES, makeup can completely alter a face – as a matter of fact, the whole appearance of the sitter can be changed. If you want to paint someone who habitually wears vivid or ostentatious makeup, it would be a mistake to paint them without. One of the major concerns in portraiture is to express character, and the way people dress, style their hair, and paint their faces is part of their own self-image, and is therefore of importance to you as an artist. One exercise you might try is to make some studies of a person first without makeup and then with, as in the sketches below. This will teach you a lot about creating mood in a portrait (see pages 50–1).

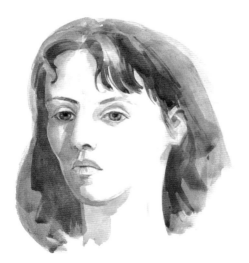 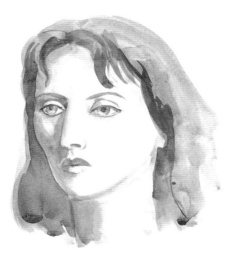

A B O V E
These watercolor studies show a dramatic difference, although the face is very obviously the seam. The "naked" face gives a soft, gentle effect, while in the made-up version the face is more sharply defined, and the eyes appear much larger.

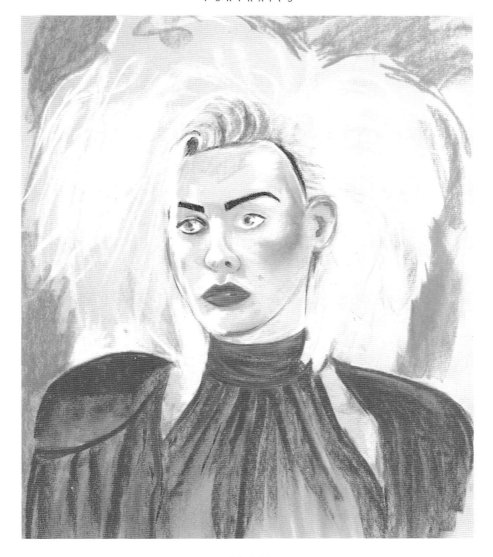

ABOVE
I made this quick pastel drawing as a
study of makeup.

EXPRESSION

THE MAJORITY of portrait paintings depict the face "in repose," that is, not smiling broadly or roaring with laughter – Frans Hals's famous *Laughing Cavalier* is a notable exception. There are two reasons for this, the first being very obvious – you cannot expect your model to maintain a smile for long, and certainly not a laugh. A less obvious reason is that an ever-smiling face can be hard to live with, as it looks somehow false. We readily accept smiles in a photograph, perhaps because we know that the camera catches a fleeting moment, but we also know that a painting takes a long time

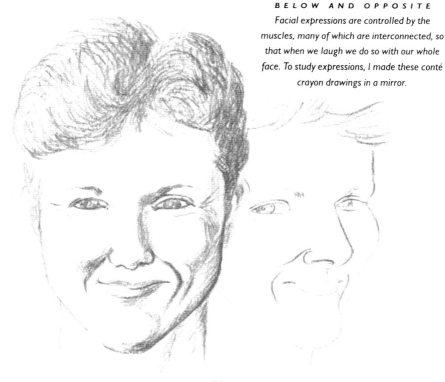

BELOW AND OPPOSITE
Facial expressions are controlled by the muscles, many of which are interconnected, so that when we laugh we do so with our whole face. To study expressions, I made these conté crayon drawings in a mirror.

and that the sitter could not possibly have been smiling all the while.

However, there is no reason why portrait drawings and quick sketches should not show smiles and laughter, and paintings, too, can give an indication of expressions, as long as they are not too extreme. To get facial expressions right you need to realize that when we smile or scowl we do so with our whole faces, because all expressions are controlled by the facial muscles. In anger, the muscles are tense and rigid, while in pleasure they relax – eyes narrow, and mouths open slightly or spread into a smile. Practice drawing yourself in a mirror, trying to make yourself feel pleased, surprised, sad or angry, and see how these emotions affect your face. Try drawing from magazines and newspapers, or from other artists' paintings.

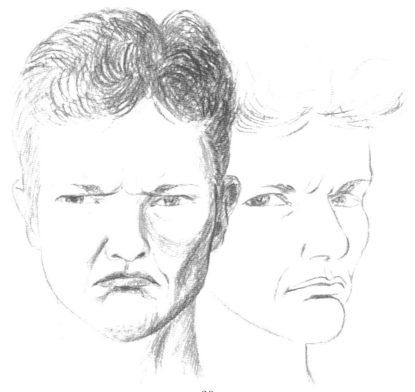

COMPOSITION:
HEAD AND SHOULDERS

THERE IS MORE TO PORTRAITURE than simply catching a likeness. If you are only sketching – perhaps making studies of a person to "learn" their features before painting them – you do not have to worry about "composing" your drawing in a particular way. However, if you intend to produce a finished portrait you must consider composition. This means designing the drawing or painting, not just plonking down a head in the middle and hoping for the best.

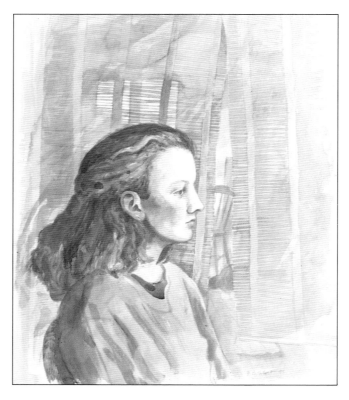

RIGHT

In this watercolor portrait I chose to leave more space on the right, where the sitter is looking, thereby drawing attention to the direction of her gaze. The window and bamboo blinds provide a lively background, but one that is not too obtrusive. The face is always the center of interest, so any other elements must play a secondary role.

If you have decided on a head and shoulders portrait you will need to consider what the background should consist of, what viewpoint you will take, and where you will place the head. If you have chosen a three-quarter view, for example, you might leave more space on the side of the shoulder farthest away, and butt up the near one to the edge of the picture. You also need to think about how much space to leave above the head. Too much may make it appear pushed down, as though about to slip out of the bottom of the picture, while too little can give a cramped, uneasy feeling.

There are many different ways of composing even a head and shoulders portrait. The examples here may give you some ideas, but I recommend that you make some small pencil sketches to try out possibilities before you begin.

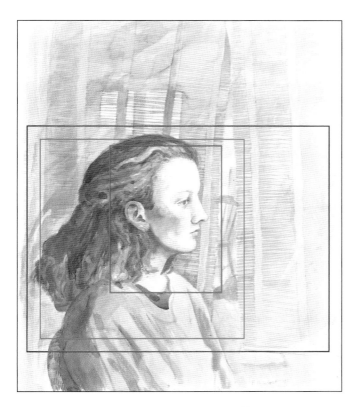

LEFT
Here you can see the variety of choices open to you in any one portrait. I could have chosen a horizontal or square format instead of a vertical one, or I could have focused in closely on the face, cropping the head at the top and left side.

Square format.

Horizontal format.

Cropped format.

COMPOSITION:
THE WHOLE FIGURE

PORTRAITS THAT include the whole of the sitter's body – feet and all – are somewhat trickier than head and shoulders portraits, simply because they involve so much more drawing. Unless you are experienced, it is easy to find that you have made the head too big and therefore have not left room for the feet, and so have to chop the figure off at the ankles. Or perhaps you are halfway through a painting, see that the head is too small, and have no room to enlarge it.

But take heart – these things happen even to professionals. The best way to avoid them is to take careful measurements, holding up a pencil as shown on pages 26–7 and marking off important points, such as the distance from head to neck, neck to waist, and so on.

You will often have more in the way of background and "props" in a full-length portrait, too, so think about what setting the picture needs. If your model is seated, choose a chair that you like to paint and that will enhance the composition.

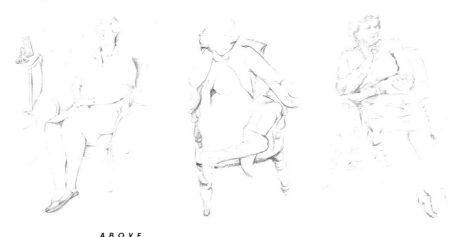

A B O V E

In all these pencil drawings, the chair is very much part of the composition, as well as supporting the sitter comfortably. When drawing seated figures, it *can be easier to sketch in the chair first and then fit the figure into it, rather than trying to fit the chair around the figure.*

42

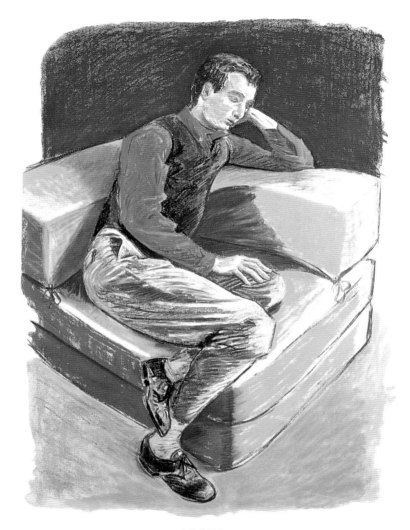

ABOVE

*In this pastel drawing, the seat and back of the chair
make two opposing triangles in which the model is
enclosed, the dark background highlighting his face.*

43

GROUP PORTRAITS

THE IDEA OF DRAWING OR PAINTING more than one figure may sound daunting, but if you have tackled a portrait of a whole figure it would be challenging to try a group. A full-scale group portrait can present practical problems, as it is hard enough to arrange for one person to sit for their portrait, let alone several, but you can make informal portrait studies of the kind shown here. If you want to make a more formal picture – perhaps a painting of different generations, or your family – consider working from sketches and photographs; many group portrait commissions are carried out in this way.

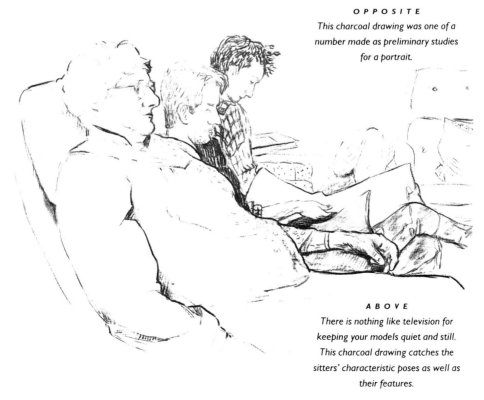

OPPOSITE
This charcoal drawing was one of a number made as preliminary studies for a portrait.

ABOVE
There is nothing like television for keeping your models quiet and still. This charcoal drawing catches the sitters' characteristic poses as well as their features.

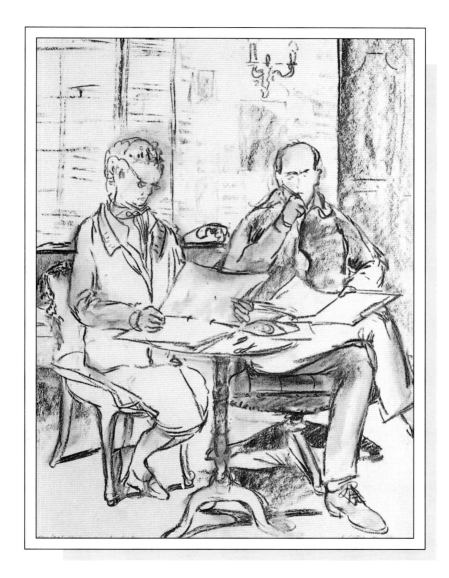

HANDS IN PORTRAITS

IF YOU ARE PAINTING only head and shoulders portraits you need not concern yourself with hands, but they can be very important in portraiture. Not only are they wonderfully expressive in themselves; they can also be used as a compositional balance to the head. My portrait of an old man on page 51 is an example of the use of hands in portraiture. In many paintings hands are treated more broadly than the face, which is the center of interest – sometimes they are dealt with in just a few brushstrokes. But to simplify any form you first need to understand it, so practice drawing hands, starting with your own.

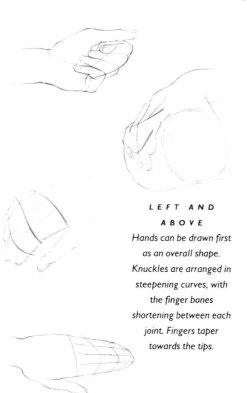

L E F T A N D
A B O V E
Hands can be drawn first as an overall shape. Knuckles are arranged in steepening curves, with the finger bones shortening between each joint. Fingers taper towards the tips.

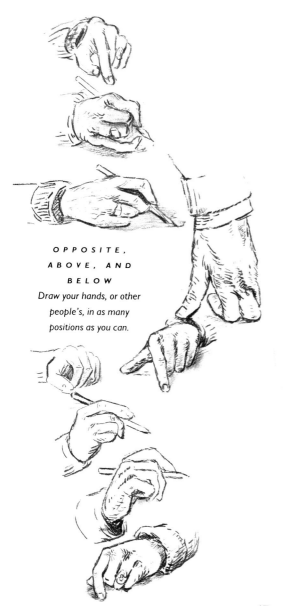

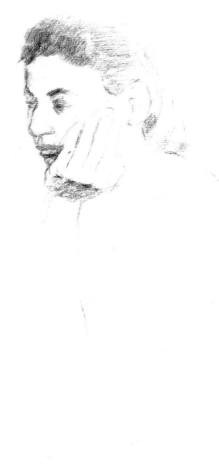

OPPOSITE, ABOVE, AND BELOW
Draw your hands, or other people's, in as many positions as you can.

ABOVE
It is natural to sit with the chin resting on a hand, and this pose makes an expressive and attractive portrait subject.

47

CLOTHING

IF YOU FIND IT DIFFICULT to draw hands and wrists, necks and arms, then look for useful clues. Clothing, although it may seem to present an extra difficulty, is often helpful in this context. You can see the shape of the wrist more clearly,

for example, if it has a watch strap going around it, and the top of a sleeve will often obligingly define the round-ness of an arm. Collars, necklaces, and rings are all good indicators of form, providing contours to be followed.

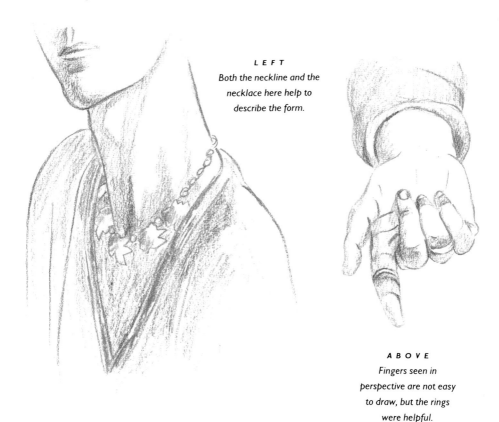

L E F T
Both the neckline and the necklace here help to describe the form.

A B O V E
Fingers seen in perspective are not easy to draw, but the rings were helpful.

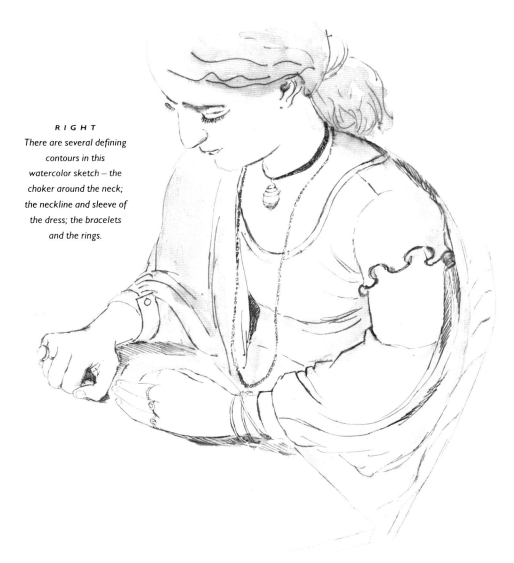

There are several defining contours in this watercolor sketch – the choker around the neck; the neckline and sleeve of the dress; the bracelets and the rings.

49

COLOR AND MOOD

EARLIER IN THIS BOOK we looked at the differences between a made-up and unmade-up person. These differences affect not only the sitter but also the painting. People often put on bright clothes or bright makeup to cheer themselves up, and color is used in painting in the same way – to express or capture a mood. If you are painting a child you would want a light, "young" mood, and would probably choose bright or delicate colors without really thinking about it. However, you may want to create a somber mood, in which case you could express it by using a muted or dark color range. If you are working in an opaque medium, such as oils, acrylics or pastels, you can also convey a good deal by the way you use the medium. For example, energetic swirling brushstrokes *à la* Van Gogh give a feeling of excitement, sometimes even of unease, while smoother treatments are more restful.

R I G H T

In this painting, done in pastel over watercolor, the colors are light and delicate, and the picture's surface is broken up into a series of individual marks, which create a busy, lively impression.

O P P O S I T E

The colors in this pastel drawing are subtle and subdued, and the mood is quiet and pensive.

50

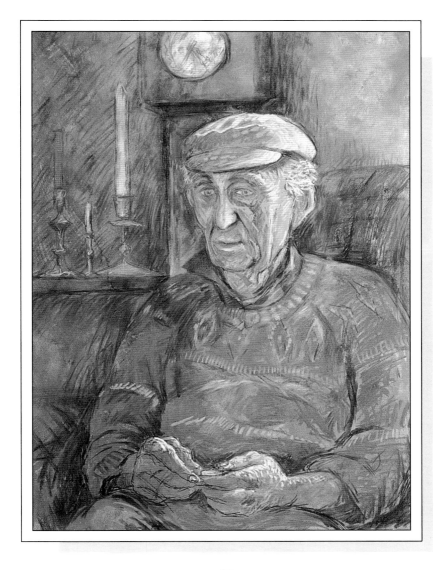

UNUSUAL LIGHTING

WITHOUT LIGHT there is no color, so it follows that you can influence the color scheme of your portraits, not only by choosing particular colors to paint with, but also by arranging specific lighting conditions. When you are starting out in portrait painting you will probably want to restrict yourself to "normal" lighting, such as illumination from a window, but sometimes you see interesting effects such as sunlight filtered through a colored blind, or a lamp casting a yellow glow on one side of a face. As you grow more experienced you can experiment with these, setting up lighting effects specially to create a particular "feel."

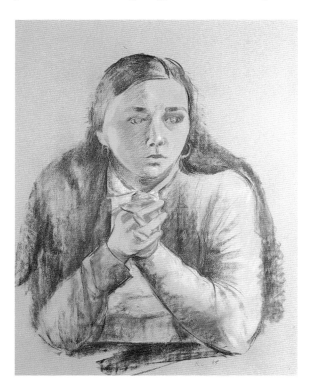

LEFT
Here I arranged the lighting deliberately, placing colored gels over two lamps, one on each side of the model.

OPPOSITE
The figure is strongly lit by lamplight, producing a lovely golden glow. I used pastel for this portrait, as it is a wonderfully colorful medium as well as being quick to use.

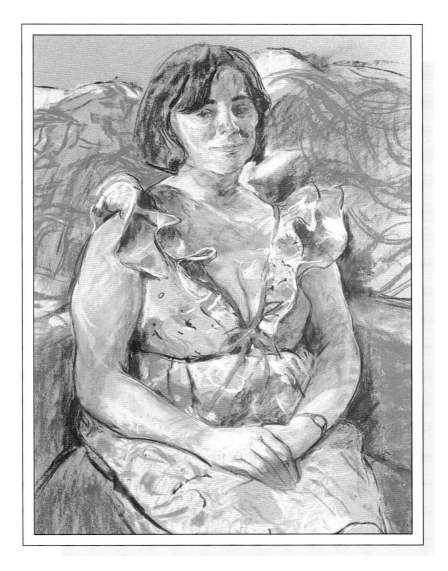

SKIN TONES

STUDENTS AND BEGINNERS often believe that there is some magic recipe for skin tones, but sadly there is not – although most artists have their preferrerd palettes. The trick is to begin by establishing the overall color of the person's face. Even within the same ethnic group, face colors vary enormously; "white" skins can be pinkish, olivey, creamy, or even dark brown or red if the person has an outdoor occupation.

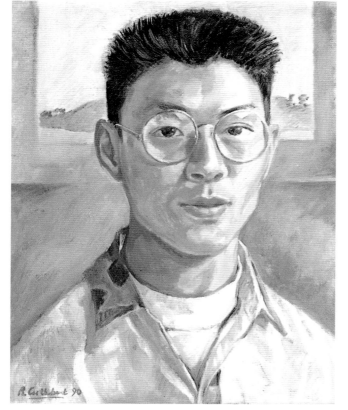

R. Cuthbert 90

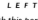

LEFT

For both this portrait and the one opposite I worked in oils. Here the "base color" was yellow ocher and raw sienna, with some white and a little lemon yellow – notice that the shadowed side of the face is quite bright. I also used a little cobalt blue and cadmium red in mixtures, and some rose madder for the lips.

OPPOSITE

For this pale skin, the basic mix was rose madder, lemon yellow, and white, which was "purpled up" with cobalt blue for the shadows. A very little raw umber was used around the eyes, and the freckles were small dabs of yellow ocher.

54

You can help yourself in this initial color assessment by half-closing your eyes, which will blur the features and any other details and give you a broad impression of both the color and the tone (lightness or darkness) of the skin.

Once you have worked this out you can try a basic mixture, which you can then add to or subtract from for shadows and highlights. For example, you might see that a face is basically a light yellowish brown, which could be achieved by mixing yellow ocher and raw umber, with perhaps a tiny touch of red. This could be lightened with white and/or more yellow, and darkened by the addition of greens, blues, and browns.

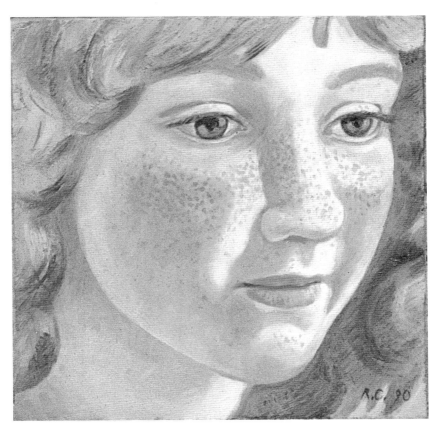

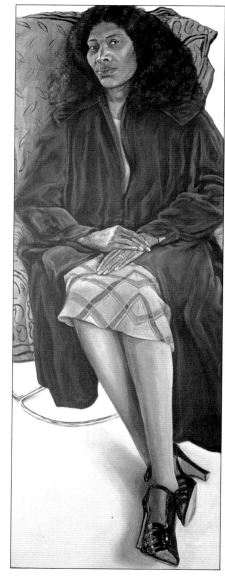

RIGHT
This oil painting was an exciting portrait to paint, as I could exploit the contrast between the golden-brown skin and the deep blue robe. I worked on a magenta underpainting, which provided a "key" for the applied colors.

OPPOSITE
For the skin, raw umber was mixed with cadmium orange and Venetian red, "cooled" in places with cerulean blue.

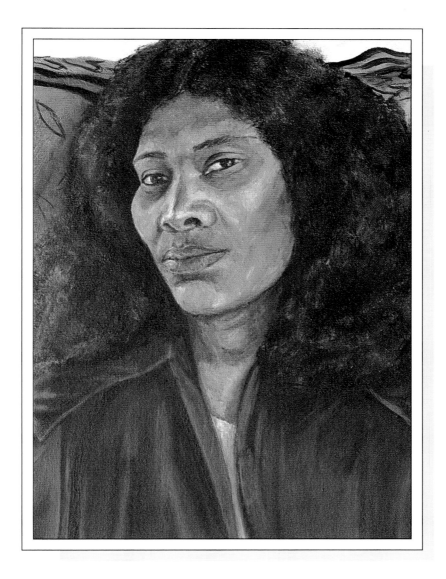

DEMONSTRATION

FOR PORTRAITURE I usually choose either oils or pastels, and in this case am using oils. I paint quite thinly, diluting my colors with turpentine alone rather than the more usual oil and turpentine mixture, as I dislike very oily paint. For this reason I have chosen a slightly absorbent builder's board to work on. My improvised palette is also board, which absorbs some of the excess oil. I like to work on a colored surface, and have painted the board with an all-over yellow "ground" that tones in with the yellow drape behind the model.

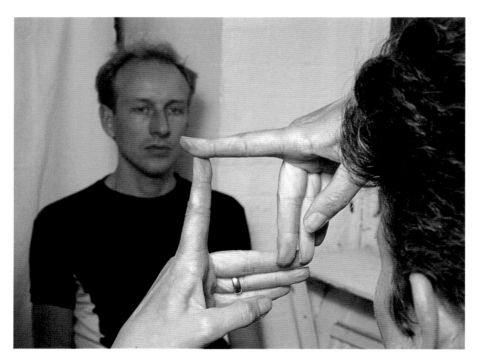

1 This is to be a head and shoulders portrait, so the first step is to decide where to place the head. I use my fingers as a "viewfinder." You can also use a piece of card with a rectangular window cut in it.

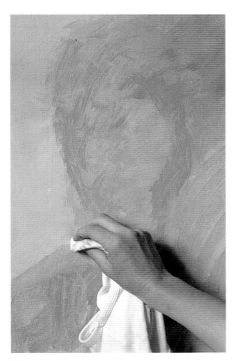

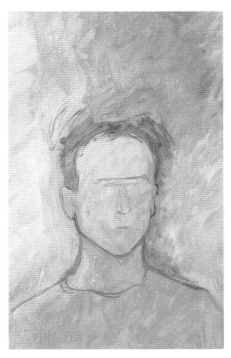

2 I begin with a nebulous mass of color to establish the overall color scheme of the painting. Here I am using a rag to spread and soften the color, since I would like to avoid any hard lines at this stage.

3 It is important to make a relationship between the head and the background, so in the early stages I use the same blue for both.

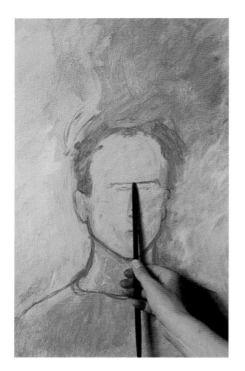

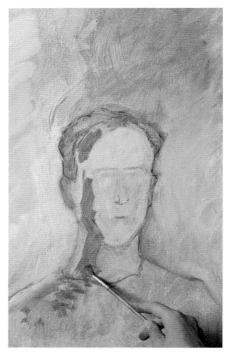

4 I have now begun to define the face and head, marking in the midpoint of the head – and the top of the eyes. I check my drawing by holding up a paintbrush at arm's length and measuring from eyebrow to chin.

5 The next stage is to begin building up the forms of the face. The strong red-brown I am using will be modified by other colors later.

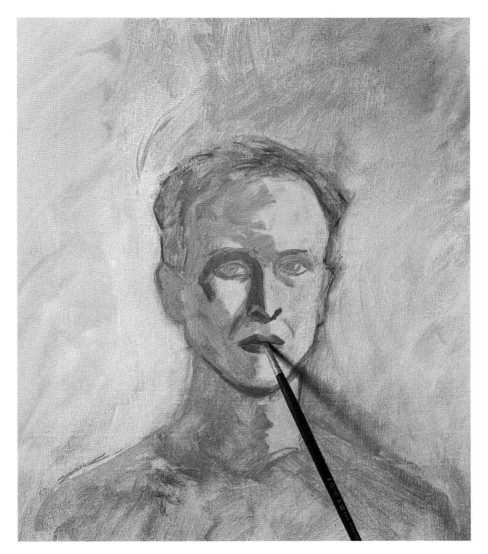

6 The features are built up gradually. Having indicated the shape of the eyes, I now begin to define the mouth, using a small, square-ended, sable brush.

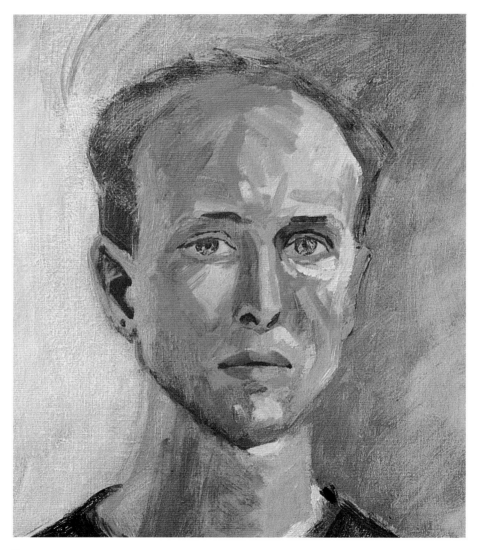

7 Further work has been done on the features, and the face is now firmly modeled. I use the paint more thickly at this stage of the painting.

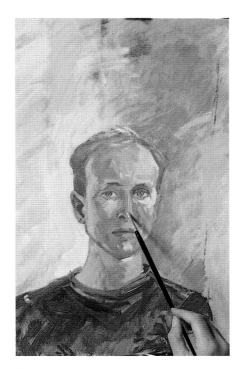 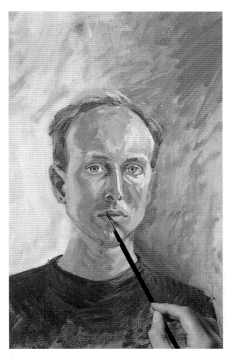

8 Highlights are now added. Notice that I have introduced a reasonably bright yellow on the right side of the face where it catches reflected light from the yellow backcloth.

9 Blue-gray shadows on the forehead, cheekbone, and chin have given the face strength and solidity. Final touches of definition are now added to the sitter's individual features.

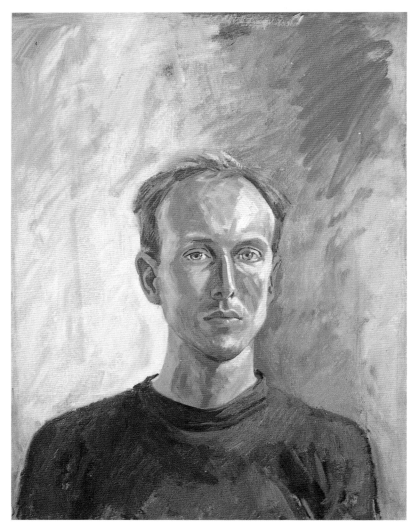

10 I made the decision to place the head fairly low down because I originally wanted to use the line of the wall in the background as part of the composition. Later, however, I decided to leave the background unspecified.